GW00326583

CONTENTS

SECRET EDINBURGH

Jack Gillon

AMBERLEY

ACKNOWLEDGEMENTS

Thanks to my good friends, David McLean and Fraser Parkinson, of Lost Edinburgh (www.facebook.com/lostedinburgh), for their help and support. Special thanks to Peter, Carol, Gregor and Isla – we had a great day taking photos and having coffee and cake in the Old Town on a misty first day of summer. Last, but not least, thanks to my wife, Emma Jane, for her patience and encouragement.

Jack

Beautiful as she is, she is not so much beautiful as interesting. In a word, and above all, she is a curiosity.

Robert Louis Stevenson on Edinburgh

First published 2015

Amberley Publishing
The Hill, Stroud, Gloucestershire, GL5 4EP
www.amberley-books.com

Copyright © Jack Gillon, 2015

The right of Jack Gillon to be identified as the Author of this work has been asserted in accordance with the Copyrights, Designs and Patents Act 1988.

ISBN 978 1 4456 3969 7 (print)
ISBN 978 1 4456 3981 9 (ebook)

British Library Cataloguing in Publication Data.
A catalogue record for this book is available from the British Library.

Typesetting by Amberley Publishing.
Printed in Great Britain.

INTRODUCTION

Secret Edinburgh aims to uncover some of the weird and wonderful people, buildings and events that have contributed to Edinburgh's long and colourful story.

Edinburgh's secret nature is reflected in the life of Deacon William Brodie – model citizen by day and dissolute thief by night. Brodie was born into a respectable Edinburgh family in 1741, and rose to become Deacon of the Guild of Wrights and a Freeman of the City. He was considered an upstanding man of respectable connections who moved in good society all his life, unsuspected of any criminal pursuits.

He was the proprietor of a locksmith and cabinet making business in the Lawnmarket and this seemingly reputable façade concealed a private life that included a passion for cockfighting, two mistresses with five children between them and a predilection for gambling. These put him under considerable financial pressure, which he relieved by carrying out a series of robberies on premises to which his trade as a locksmith had given him nefarious access.

He was eventually arrested in Amsterdam, where he had gone on the run. Brodie was hanged on the Tolbooth gallows which he had designed in 1788. His double life is said to have contributed to Robert Louis Stevenson's inspiration for the story of Dr Jekyll and Mr Hyde.

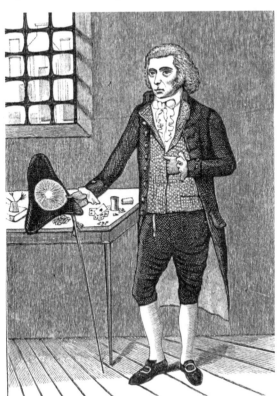

John Kay's portrait of Deacon Brodie with copied keys, a pistol and cards.

THE HOLYROOD ABBEY SANCTUARY

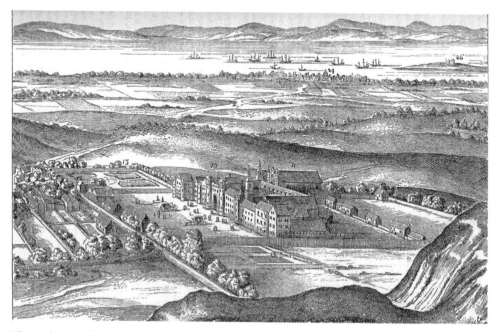

The Holyrood Abbey Sanctuary.

A number of Edinburgh Old Town's former important historic buildings are usefully marked in the roadway of the Canongate and the High Street. At the Holyrood end of Edinburgh's Canongate, a circle of cobbles in the centre of the road marks the site of the Girth Cross, which has also been called the 'Abbey' or 'South' Cross at various times. The Cross was a place for public proclamations, civic and trading activity, as well as for executions. It also marked the western boundary of the Holyrood Abbey Sanctuary, within which debtors were immune from arrest. The limits of the Abbey Sanctuary are also marked by s-shaped brass studs in the paving of the street.

The Sanctuary was established in the twelfth century, under a charter granted by King David I, and was originally extended to criminals. The first record of a debtor taking sanctuary in Holyrood is in 1531.

Once over the boundary line between the Canongate and the abbey, debtors had to make a formal application to the Bailie of Holyrood for the 'benefit and privilege' of sanctuary within 24 hours or risk being ejected. After considering the case, and on payment of a booking fee, the applicant was presented with 'letters of protection' showing that he had been admitted to the Sanctuary. The debtor was then safe to live within the Sanctuary, free from risk of arrest.

The Sanctuary's area was extensive, including Arthur's Seat and the Royal Park, stretching southwards to Duddingston and Newington and eastwards to Jock's Lodge.

All the habitable houses, some of which survive in the Abbey Strand, were crowded around the foot of the Canongate and accommodation for debtors was available in lodging houses and inns.

In addition to the debtors, who were commonly known as the 'Abbey Lairds', there was a general community of tradesmen, shopkeepers, innkeepers and residents who chose to live within the Sanctuary. The Bailie of Holyrood was responsible for keeping law and order within the Sanctuary, which was outside the control of the Edinburgh magistrates. This gave the Abbey Sanctuary the feeling of being a small town in its own right, independent of control from Edinburgh.

At midnight on a Saturday, the 'Abbey Lairds' could safely leave the Sanctuary for 24 hours of freedom as, under Scot's Law, legal proceedings could not be taken on a Sunday. Most of them took advantage of this opportunity to visit friends or go to church.

The population of debtors included clergymen, lawyers, officers of the army and navy and members of the aristocracy. Thomas De Quincy, author of *Confessions of an English Opium-Eater*, was resident in the Sanctuary at various times between 1835 and 1840.

Another famous resident was Charles-Philippe, Comte d'Artois, brother of the deposed Louis XVIII of France. His first arrival in 1796 was prompted by the massive debts he had incurred supplying the émigré army after the French Revolution. He returned in 1830, after reigning briefly as Charles X, complete with his royal retinue of 100, most of whom lodged in the Canongate. The ancient right of sanctuary within the grounds of Holyrood has never been repealed, however, the need for a debtors' sanctuary ended in 1880 when imprisonment for debt was abolished.

Above: Sanctuary marker.

Right: Site of the Girth Cross.

NETHERBOW PORT

For centuries the Netherbow Port acted as the principal gateway into the old city of Edinburgh. It is mentioned as early as 1369, but a more elaborate version was conceived along with the Flodden Wall in 1513. Brass plates set into the roadway at the junction of the High Street and St Mary's Street/Jeffrey Street mark its outline.

Edinburgh was historically protected by a wall on three sides and by the Nor' Loch, an artificial area of water to the north of the town. The earlier King's Wall enclosed a small portion of the current Old Town, running east from the Castle rock above the Grassmarket towards Blackfriars Street. This was extended after the disastrous defeat of the Scottish army at the Battle of Flodden in 1513.

The Netherbow Port was built from 1513 as part of the Flodden Wall defences and was the most important of the six gateways located at each of the major routes into the city. Unfortunately, the defences seldom offered the desired protection and were breached on a number of occasions. Despite their defensive limitations, the gateways and walls still served the city well by controlling trade – the gate was the place where 'tack' or customs duty was levied on goods entering the city. Edinburgh was a separate burgh from the Canongate area on the other side of the Netherbow Port, until it was officially absorbed into the city in 1856.

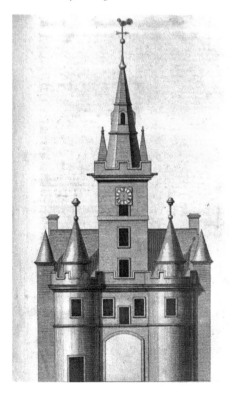

Netherbow Port.

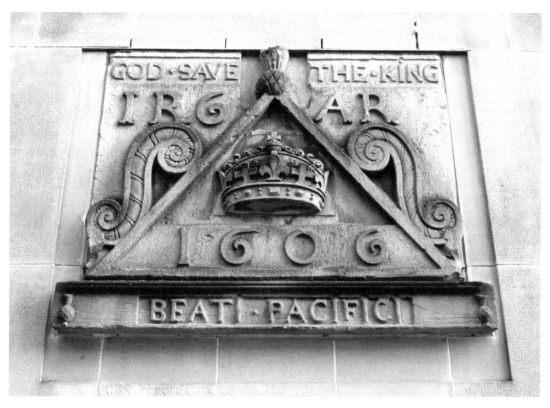

Above: Netherbow Plaque.

Right: Reconstruction of the Netherbow Port for the 1886 International Exhibition.

The Netherbow Port was badly damaged during an invasion in 1544. The gateway was subsequently rebuilt and remodelled in 1603. Its distinctive two-storey spired tower above its main arched gateway featured an elegantly crafted clock. The Netherbow Port was one of the finest structures in Edinburgh and the most attractive of all its gates. However, this did not stop the city's lawmakers from using the Netherbow Port as a crime deterrent – the heads of executed criminals were gruesomely exhibited on the Netherbow. A sight that would surely have made a lasting impression on visitors to the city.

The demolition of the Netherbow Port went ahead in 1764, by order of the city magistrates. In the post-Culloden era it was no longer required as a defensive structure and was widely regarded as an obstruction to the flow of traffic and an out-dated restriction on free trade.

The Netherbow Bell – which was sounded as prisoners went to their deaths – and the port's plaque were both recovered and can be seen at the Netherbow Centre. The plaque was made to honour James VI's survival of the Gunpowder Plot in 1606 and incorporates James' favourite motto 'beati pacifici' – meaning 'blessed are the peacemakers'. The clock and weathervane from the port were also salvaged and given to the Orphan Hospital, then near Trinity Hospital, before their move to what is now the Dean Gallery, where the clock remains on the pediment. Significant parts of the city walls can also still be seen at the Vennel, Greyfriars Kirkyard, and at the corner of Drummond Street and the Pleasance.

A reconstruction of the Netherbow Port formed the centre piece of the medieval Edinburgh exhibit at the International Exhibition of 1886.

THE EDINBURGH TOWN GUARD

Brass plates in the roadway of the High Street opposite Stevenlaw's Close, just west of Hunter Square, mark the location of the former Town Guard House.

The Edinburgh Town Guard was formed in 1682 to carry out the function of a local police force. The guard consisted of three companies of 1 captain, 1 sergeant, 1 corporal, 1 drummer, and 25 privates. They were generally responsible for keeping order and would beat their drums through the Old Town at eight o'clock as a kind of curfew.

According to one contemporary writer, its ranks were composed mainly of 'old Highlanders, of uncouth aspect and speech, dressed in a dingy red uniform and cocked hats, who often exchanged the musket for an antique native weapon called the Lochaber axe'. On night duty the guards were issued with rattles to sound the alarm in case of fire or riot.

The guard house was a long, black slated building of four apartments, one storey in height. It was described by Walter Scott as 'a long black snail crawling up the middle of the High Street'. A wooden horse was kept outside the building and this was used as an unusual punishment for people found drunk and disorderly; they would be made to sit for a length of time on the horse with heavy muskets attached to their feet. The guard house was demolished in 1785 and the town guard moved to the Tolbooth.

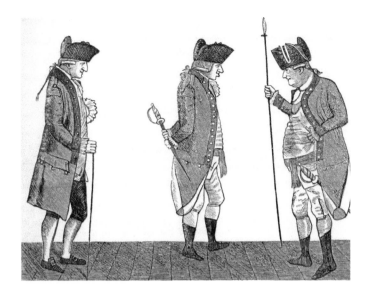

Captains of the town guard.

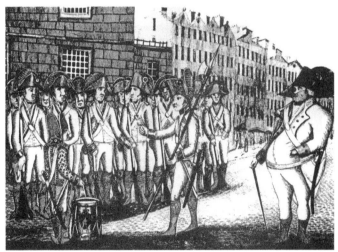

The town guardsmen.

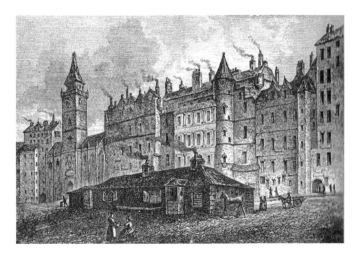

The Guardhouse.

The town guards, or town rats as they were known, were not taken particularly seriously, and by the time they were disbanded in 1817 they had become 'an unfailing subject of mirth to the citizens of Edinburgh'.

THE LUCKENBOOTHS

Up until the early nineteenth century, the flow of traffic on Edinburgh's busy High Street was restricted to just a few metres by a group of buildings known as the Luckenbooths. Brass plates on the High Street side of St Giles now mark its location.

The earliest method of selling merchandise in medieval Edinburgh was from stalls in one of the city's marketplaces. Artisans and craftsmen soon required a more permanent base for their specialised workshops and, in 1440, timber-fronted two-storey buildings, called the 'buith-raw', were erected on the High Street running parallel to the north of St Giles. Over the years, the buith-raw was extended and heightened until it consisted of seven tenement buildings stretching the full length of St Giles. They were renamed the 'Luckenbooths', from the fact that the buildings contained shops in lockable booths.

The Luckenbooths were linked at their west end to the Bell-house, the meeting place of the Edinburgh guilds, and the Tolbooth – Sir Walter Scott's Heart of Midlothian. The Luckenbooths were the focus of trade and business for centuries. The shops dealt in a wide range of goods and services, including Peter Williamson's Penny Post Office and Alan Ramsay's circulating library, from where he 'diffused plays and other works of fiction among the people of Edinburgh'. Ramsay's shop at the easternmost end of the Luckenbooths was later used by William Creech

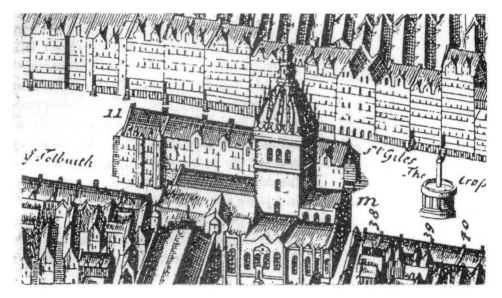

The Luckenbooths.

Creech's bookshop at the east end of the
Luckenbooths.

as a bookshop which became the 'natural resort of lawyers, authors, and all sorts of literary idlers who were always bustling about this convenient hive'. Creech was responsible for the publication of the early works by Burns.

In the narrow passage left between the Luckenbooths and St Giles there were bazaar-style market stalls called Krames. The Krames were 'singular places of business, often not presenting more space than a good church pew' and the stalls specialised in hardware, leather goods and toys. Official town orders to prevent the emptying of chamber pots and dumping of refuse from the upper residences of the Luckenbooths on to the Krames below were notoriously unsuccessful. As a result, the restricted passageway of the Krames was known as the Stinking Style.

The Luckenbooths were finally demolished in 1817, by which time the High Street, at only 15 feet wide, had become hopelessly congested. The name lives on in the shape of the heart-shaped brooches, known as luckenbooths, which are replicas of those in vogue in Scotland during the early 1700s. They were traditionally exchanged between lovers upon betrothal.

THE HEART OF MIDLOTHIAN – EDINBURGH TOLBOOTH

Brass plates in the roadway to the west of the site of the Luckenbooths outline the shape of Edinburgh's Tolbooth. The entrance to the building is also marked by a heart-shaped pattern of cobbles.

The Tolbooth was built in 1561 and was a booth for collecting tolls, a council chamber and a courthouse. After 1640, its main use was as a prison. The roof of the lower westwards extension formed a platform for the scaffold. The Tolbooth was made famous by Sir Walter Scott's book *The Heart of Midlothian*, which is based on the true story of the murder of Capt. Porteous by the Edinburgh mob.

> Deacon Brodie was the first who proved the excellence of an improvement he had formerly made on the apparatus of the gibbet. This was the substitution of what is called the drop for the ancient practice of the double ladder. He inspected the thing with a professional air, and seemed to view the result of his ingenuity with a smile of satisfaction. When placed on that insecure pedestal, and while the rope was adjusted round his neck by the executioner, his courage did not forsake him. On the contrary, even there he exhibited a sort of levity; he shuffled about, looked gaily around, and finally went out of the world with his hand stuck carelessly into the open front of his vest.
>
> *Traditions of Edinburgh*, Robert Chambers

The Tolbooth was demolished in 1817 at the same time as the Luckenbooths.

The Tolbooth.

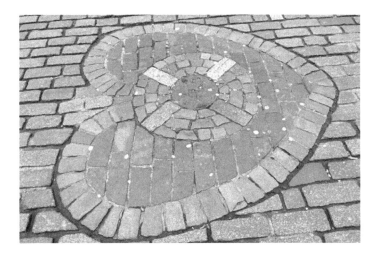

The Heart of Midlothian.

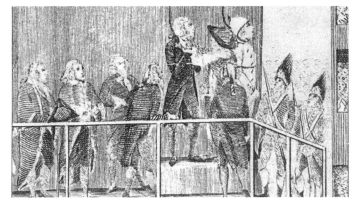

The execution of Deacon Brodie and his accomplice George Smith, 1 October 1788.

SEDAN CHAIRS

A small, stone building in Tweeddale Court is known as Sedan Chair House and historically was used to store the sedan chairs that provided a transport service in the Old Town of Edinburgh for over 100 years.

The first sedan chairs for public hire were introduced to Edinburgh in 1687. Horse-drawn coaches had been used before this, but were unsuited to the narrow closes and steep hills of Edinburgh's Old Town. The sedan chair was, therefore, a particularly suitable form of transport.

The hackney sedans were constructed of wood with a black leather covering and were fitted with a cushioned seat. Privately owned chairs were much more elaborate with fine embossed leather, stamped metalwork, pastoral paintings, carvings and gilding. The sedan door was normally at the side, but most Edinburgh chairs had a door at the front to allow easier access from doorways in the narrow closes and wynds. Another Edinburgh adaptation

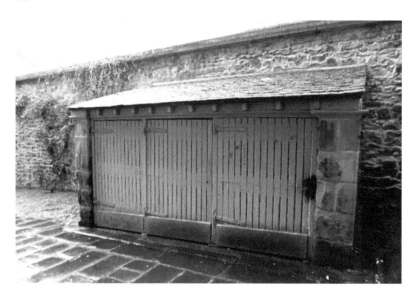

Sedan Chair House.

was the pivoting seat that kept passengers in a horizontal position on the steep inclines in the Old Town.

The sedan chair reached the height of its popularity in the eighteenth century. In 1687 there were only six chairs available for public hire, but by 1779 there were 180 hackney chairs and 50 private chairs in Edinburgh. The main sedan chair stance was at the Tron Kirk. A table of fares introduced in 1738 specified 6d for a trip within the city, 4s for a whole day's rental, and 1s 6d for a journey a half mile outside town. The majority of the chair bearers were Highlanders and this was reflected in the use of tartan for their uniforms.

The sedans were a fairly dignified method of transport as long as there was no great hurry and the distance to be travelled was not great. However, it would seem that they were not particularly comfortable, especially when the chairmen were busy, when they would 'set off at a plunging trot with their load, and as the carrying poles were quite pliant, the extreme bobbing up and down and swinging to and fro of the vehicle, produced an uneasy feeling in the passenger'.

It was a quirky taxi service. The 'ladies of nobility and quality' who used them for trips to dancing assemblies and the theatre could be sure (doubtless at a price) of a small lantern to light the sedan and a hot water pan placed under the seat.

A particularly eccentric Edinburgh judge never used a sedan himself but had his wig sent home in one when it rained. A sedan was even kept by the Royal Infirmary as an ambulance. It was quite common for sedans to be overturned in strong winds and it was normal on windy days to hire two men to walk each side of the chair to keep it even, while another two carried it. Quite how four such men synchronised their movements is not explained.

The sedan chair continued to be used for all major Edinburgh social events well into the nineteenth century, but by that time most sedans were in the more affluent New Town. There were 101 sedan chairs in 1814, only 46 in 1827 and, by 1850, horse-drawn carriages had replaced this picturesque method of transport.

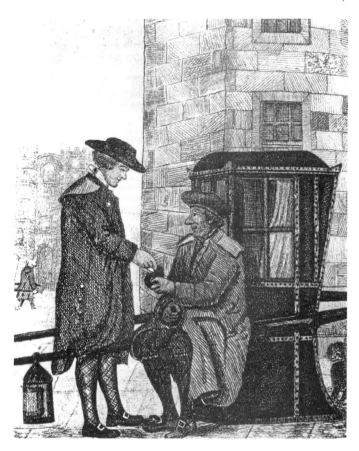

Sedan man and customer.

JOHN DOWIE'S TAVERN

The teeming nature of life in eighteenth-century Edinburgh elevated the Old Town's taverns to a critical role in the city's social life. 'Intemperance was the rule and no man of the day thought himself able to dispense with the Meridian' (the drink taken at midday). Much of the business life of the city was carried out in taverns and it was even normal for doctors to consult their patients there.

One of the most popular establishments was John Dowie's Tavern in Libberton's Wynd, a narrow lane sloping down to the Cowgate, just to the east of the junction of the present-day High Street and George IV Bridge. This 'perfect specimen of tavern' was run by 'Dainty' John Dowie. The most eminent citizens and visitors, including David Hume and Burns, frequented Dowie's 'quaint house of entertainment for its congenial company and good fare'.

The following description was typical of the taverns of the day: 'A great portion of this house was without light, consisting of a series of windowless chambers, decreasing in size till the smallest was a mere box, of irregular oblong shape, designated the Coffin.' The

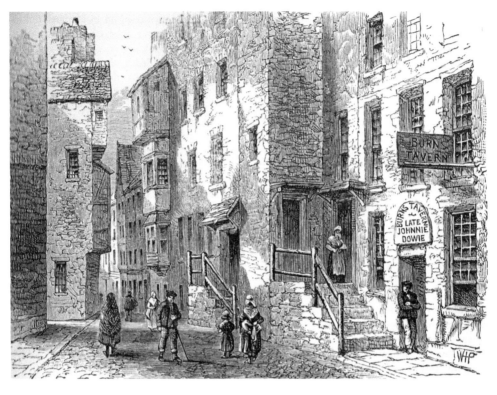

Above: John Dowie's Tavern.

Left: John Dowie.

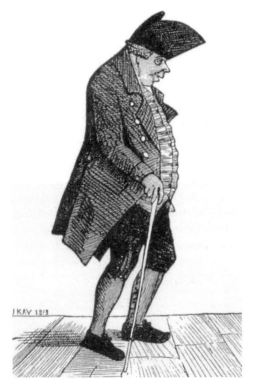

largest room could accommodate fourteen people, the Coffin held four, at a squeeze, and only two of the rooms had windows.

The Tavern was renowned for its Archibald Younger's Edinburgh Ale, 'a potent fluid that almost glued the lips of the drinker together and of which few could despatch more than a bottle', also famed for its 'petit soupers', the speciality of the house being Nor' Loch eel pie.

John Dowie was the 'sleekest and kindest of all landlords' and 'conscientious as to money matters'. He left a substantial fortune when he died in 1817. The new owner of the Tavern displayed the name 'Burn's Tavern late Johnnie Dowie' on his signboard, capitalising on the fame of the previous landlord and the link with Burns.

JOHNNIE DOWIE'S ALE

A' ye wha wis', on e'enings lang,
To meet an' crack, and sing a sang,
And weet your pipes, for little wrang,
To purse or person,
To sere Johnnie Dowie's gang,
There thrum a verse on.

O, Dowie's ale! Thou art the thing,
That gars us crack, and gars us sing,
Cast by our cares, our wants a' fling
Fraw us wi' anger;
Thou e'en mak'st passion tak the wing,
Or thou wilt bang 'er.

How blest is he wha has a groat
To spare upon the cheering pot;
He may look blithe as ony Scot
That e'er was born:
Gie's a' the like, but wi' a coat,
And guide frae scorn.

But thinkna that strong ale alone
Is a' that's kept by dainty John;
Na, na; for in the place there's none,
Frae end to end,
For meat can set you better on,
Than can your friend.

Wi' looks a mild as mild can be,
An' smudgin' laugh, wi' winkin' e'e;
An' lowly bow down to his knee,
He'll say fu' douce,
'Whe, gentlemen, stay till I see,
What's i' the house.'

Anither bow, 'Deed, gif ye please,
Ye can get a bit toasted cheese,
A crum o' tripe, ham, dish o' pease,
(The season fittin',)
An egg, or, cauler frae from the seas,
A fleuk or whitin';

A nice beefsteak, or ye may get
A gude buff'd herring, reisted skate,
An' ingans, an' (tho' past its date),
A cut o' veal;
Ha, ha, it's no that unco late,
I'll do it weel.'

Then pray for's health this mony year,
Fresh three-'n-a-ha' penny, best o' beer,
That can (tho' dull) you brawly cheer-
Recant you week up;
An' gar you a' forget your wear-
Your sorrows seal up.

INDIAN PETER

Peter Williamson, or 'Indian Peter' as he became known, was one of the more colourful personalities of eighteenth-century Edinburgh. He had a remarkable life of amazing adventure.

Peter was born in 1730, the son of a crofter, in Aboyne, Aberdeenshire. His parents were 'reputable, though not rich', and they sent him as a young boy to live with an aunt in Aberdeen. At this time, kidnapping was a flourishing business in Aberdeen. Children were regularly kidnapped for sale in American plantations and a number of the Aberdeen City Bailies, who were in partnership with the kidnappers, amassed fortunes from this 'hideous traffic in human merchandise'.

At the age of eight, Peter was on the harbour at Aberdeen when he was 'taken notice of by two fellows employed by some worthy merchants of the town, in that villainous practice called kidnapping'. He was 'marked out by these monsters as their prey and taken forcibly on board a ship', where he was locked up below decks with around sixty other boys and shipped across the Atlantic to America.

Peter was then sold as a slave in Philadelphia for the 'handsome sum' of £16. He was indentured for a period of seven years to a fairly well off planter, Hugh Wilson, who had himself been kidnapped as a boy. Just as Peter's period of indenture was about to end, Wilson died and bequeathed Peter '£120, his best horse, saddle and all his wearing apparel'.

 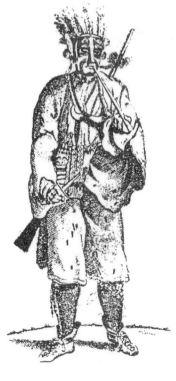

Left: Peter Williamson.

Right: Peter Williamson in the dress of a Delaware Indian.

At twenty-four, Peter married the daughter of a wealthy planter. His father-in-law provided a dowry of 200 acres of land on the frontiers of Pennsylvania, and Peter settled down to his new life. However, marauding Indians began to prove troublesome, instigated by the French who paid £15 for every British scalp taken. On the night of 2 October 1754, Peter was in his house alone when Cherokee Indians surrounded it. He was captured, and his house was plundered and burned. He was force-marched many miles, witnessing along the way the murder and scalping of numerous settlers. Peter somehow managed to survive and made a daring escape from his captors.

Shortly after, he enlisted in one of the army regiments established to combat the French and Indians in the colonial war. For three years he served as a soldier, rising to the rank of lieutenant and was present at the Battle of Oswego in 1756, where the British forces were compelled to surrender and he was taken a prisoner of war by the French. After being marched to Quebec, Peter embarked as an exchange prisoner on a ship bound for Plymouth, where he arrived in November 1756.

He arrived penniless in York, where he was fortunate enough to interest 'certain honourable and influential men' in his case. They assisted him in the publication of an account of his unusual adventures and experiences. The book was titled *French and Indian Cruelty, Exemplified in the Life and Various Vicissitudes of Fortune of Peter Williamson: Who was Carried Off from Aberdeen in His Infancy, and Sold as a Slave in Pennsylvania.* It gave remarkably good value for money, made excellent reading and created quite a stir in York. A thousand copies were sold and Peter made a net profit of £30 with which to continue his journey to Scotland.

On his travels northwards, he made some additional money by selling copies of his book and giving displays of Indian life: 'Armed to the teeth and painted like a Red Indian, he would enter a town, whooping and screeching until he had attracted a sufficiently large crowd. Then he would windmill his arms madly and give his impression of a war-dance.' At the end of the show, he would take up a collection and sell copies of his book.

In June 1758, Peter finally arrived in Aberdeen, where his exhibition of American Indian culture attracted great crowds and his book sold well. The details of his kidnapping horrified the Aberdeen public. The merchants and magistrates of Aberdeen also took note of the book, particularly the part that accused them of being involved in the kidnapping business, and Peter was charged with offering for sale a 'scurrilous and infamous libel upon the merchants and magistrates of the town'. Copies of the book were seized and burned at the market cross by the common hangman. Peter was imprisoned until he signed a declaration that the account of his kidnapping was false, he was then fined 10s and banished from Aberdeen as a vagrant.

Peter made his way to Edinburgh, and found the city and its people much to his liking. Peter opened a coffee house in the old Parliament Hall, which was then a meeting place associated with the adjoining law courts. His coffee house soon became a favourite meeting place of lawyers and their clients. The establishment consisted of 'three or four very small apartments, one within another; the partitions made of the thinnest materials; some of them even of brown paper'.

Robert Fergusson's poem, 'The Rising of the Session', described the lawyers departing for their summer break and devotes a verse to Peter's coffee house:

> This vacance is a heavy doom
> On Indian Peter's coffee-room,
> For a' his china pigs [bottles] are toom [empty]
> Nor do we see
> In wine the sucker bisket [sugar biscuit] soom [swim]
> As light's a flee.

Peter sold copies of his book in the coffee house and was encouraged by his lawyer customers to raise an action against the magistrates of Aberdeen. The case was heard in the Court of Session and the verdict was unanimous in Peter's favour. The Provost of Aberdeen, four Bailies and the Dean of Guild were ordered to pay a fine of £100 as compensation to Peter.

During these legal actions, Peter had also been busy in other areas. He had a lively and ingenious mind, and 'aided by the knowledge he had acquired in scenes more bustling than the Scottish Capital, he became a projector of schemes, locally new and unheard of, some visionary, but others practicable and likely to be generally useful'.

He became proprietor of a famous tavern in Edinburgh's Old Parliament Close and, as a result of his earlier adventures, the sign over the tavern read: 'PETER WILLIAMSON, VINTNER FROM THE OTHER WORLD.' Peter is described as being a 'robust, stout, athletic man and a great wag, of very jocular manners' and was a popular landlord. His occasional exhibitions, when he dressed as a Delaware Indian, were also an attraction of considerable interest. A wooden figure of him in Indian dress stood as a signpost outside the tavern. The Edinburgh magistrates assembled at Peter's tavern for the 'deid chack', the dinner they took after attending a hanging. His flamboyant character even extended to the manner in which he signed his name with a flourish – 'P. Wm. Son' – with 'son' lower down the page than 'Wm.'

In 1773, Peter compiled Edinburgh's first street directory. This pioneering work contained an 'alphabetical list of names and places of abode of the Members of the College of Justice, public and private gentlemen, merchants, and other eminent traders; mechanics, carriers, and all persons in public business: where at one view, you have a plain direction, pointing out the streets, wynds, closes, lands, and other places of their residence in and about the metropolis'. The directory cost 1s and Peter continued to publish it until 1796.

The directory was a product of his new business venture, a printing house in the Luckenbooths. In 1769, he had brought a new portable printing press from London and taught himself the craft of printing. He also invented a portable printing press which was able to print two folio pages, 'with the greatest expedition and exactness', and he would travel with his press to country fairs giving 'exhibitions of the wonder of printing to the astonished rustics'. At the same time, he developed stamps and ink for marking linen and books, 'which stands washing, boiling and bleaching, and is more regular and beautiful than any needlework.' Another of his inventions was an early example of a basket scythe, which he described as 'being able to do more execution in a field of oats in one day, and to better purpose, than it is the power of six shearers'.

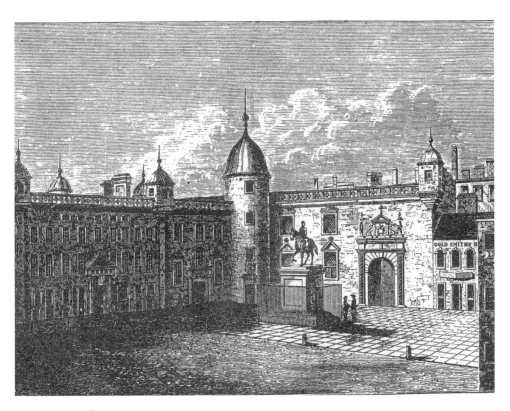

Parliament Hall.

In 1776, he launched a weekly periodical, *The Scots Spy* or *Critical Observer*, which ran for a total of ten months. It was published every Friday and consisted of a mixture of local gossip and articles.

During the time that Peter ran the coffee house, he was frequently asked to arrange the delivery of letters and he employed a man to deliver them for a small charge. This gave Peter the idea for one of his most successful ventures – a regular postal service throughout the city.

The earliest information about this is an advertisement in the second edition of his *Edinburgh Directory* published in 1774: 'The Publisher takes this opportunity to acquaint the Public that he will always make it his study to dispatch all letters and parcels, not exceeding three pounds in weight, to any place within an English mile to the east, south and west of the cross of Edinburgh, and as far as South and North Leith, every hour through the day for one penny each letter and bundle.'

The main office for Peter's postal service was in the Luckenbooths and he appointed seventeen shopkeepers in different parts of the city as official receivers of letters. He employed four uniformed postmen, who wore on their hats the words Penny Post and were numbered 1, 4, 8 and 16, so that the business would seem much larger than it actually was. Peter's Penny Post was the first in Britain and he ran it for thirty years. In 1793 the Williamson Penny Post was integrated into the General Post Office and he received a pension of £25 for the goodwill of the business.

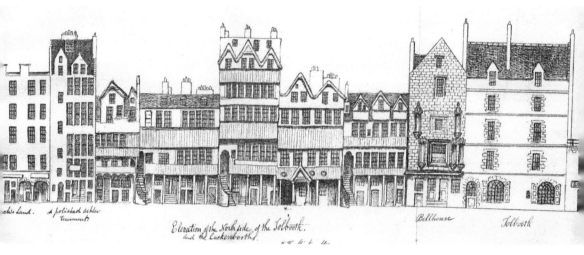

The Luckenbooths.

In Robert Fergusson's poem, 'Codicil to Robert Fergusson's Last Will', he mentions Peter's Penny Post:

> To Williamson, and his resetters
> Dispersing of the burial letters,
> That they may pass with little cost
> Fleet on the wings of penny-post.

In his latter days, Peter returned to his old business and kept a tavern at Gavinloch's Land in Edinburgh's Lawnmarket, where it is thought that he ultimately became 'addicted to drink'.

He died on 19 January 1799, and was buried in an unmarked grave in the Old Calton Cemetery, around fifteen paces north-east of the Martyr's Monument. *The Scot's Magazine* wrote:

> At Edinburgh, Mr Peter Williamson, well known for his various adventures through life. He was kidnapped when a boy at Aberdeen, and sent to America, for which he afterwards recovered damages. He passed a considerable time among the Cherokees, and on his return to Edinburgh amused the public with a description of their manners and customs, and his adventures among them, assuming the dress of one of their chiefs, imitating the war whoop, &c. He had the merit of first instituting a Penny-post in Edinburgh, for which, when it was assumed by Government, he received a pension. He also was the first who published a Directory, so essentially useful in a large city.

WITCHES' WELL

The memorial, tucked away on the side wall of what is now the Tartan Weaving Centre in a corner of the Castle esplanade, commemorates the hundreds of people persecuted for witchcraft.

In the latter part of the sixteenth century, the country was preoccupied with superstition and the need to expose those suspected of 'confederating with the Devil'. Castlehill was the location of more burning of people – mainly women – for witchcraft than any other place in Scotland.

Those accused suffered cruel torture. One test was for the accused to be 'dookit' in the Nor' Loch with their thumbs and toes tied together – drowning meant that the person was innocent; floating meant they were guilty and would meet their end at the stake on Castlehill.

The Plaque beside the Well reads:

This Fountain, designed by John Duncan, R.S.A. is near the site on which many witches were burned at the stake. The wicked head and serene head signify that some used their exceptional knowledge for evil purposes while others were misunderstood and wished their kind nothing but good. The serpent has the dual significance of evil and wisdom. The Foxglove spray further emphasises the dual purpose of many common objects.

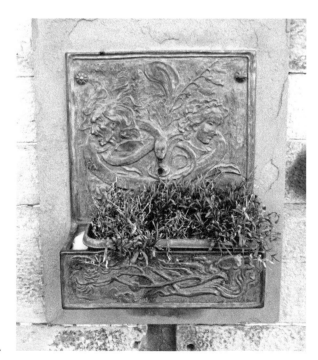

The Witches' Well.

The building now occupied by the Tartan Weaving Centre was built as a reservoir for the supply of water to the Old Town. It was built in the mid-nineteenth century to replace an older reservoir and was capable of holding 2 million gallons in a tank that occupied the whole building. It was decommissioned as a reservoir as recently as the early 1990s.

JAMES GRAHAM

Eighteenth-century Edinburgh was a popular venue for itinerant medical shows. A stage would be erected on the High Street and dancers, jugglers, acrobats and rope-dancers (who performed on a tightrope fixed between buildings on each side of the High Street) would attract a crowd. The Medicine Man of the company would then detail the curative powers of the pills, powders and potions – 'infallible' antidotes for almost all disorders. Many Edinburgh folk were gullible enough to keep them in business.

One of the most notorious of these medical quacks was 'Doctor' James Graham, who was born in the Grassmarket in 1745. In 1780 he established the lavish 'Temple of Health' in Royal Terrace, London. Here he treated patients with his imposing and elaborate electrical machines with such lethal sounding names as the 'magnetic throne' and the 'electric bath tub'. Concoctions like his 'famous aetherial and balsamic medicines' and 'elixir of life' contained ingredients which he claimed prolonged life indefinitely. Clients could also sample the richly gilded 'celestial bed', filled with stallion hair and guaranteed to cure sterility, and his 'earth bath', which promised beneficial results from being buried up to the chin in warm earth. What it benefited is not related. The 'Temple of Health' was popular at first, but soon fell out of favour and closed in 1782.

In 1783, he returned to Edinburgh where he lectured, treating patients with his electrical equipment and selling patent medicines and copies of his book, *The Guardian of Health, Happiness and Long Life*. But after his lecture, 'On the means of exciting and rendering permanent the Rational, Temperate and Serene Pleasures of the married state', he was banned from addressing the public due to the 'coarseness and indecency' of its content.

He believed that people should 'abstain totally from flesh and blood, from all liquors but cold water and fresh milk, and from 'excessive sensual indulgence', and that many human ailments were due to wearing woollen clothing. The Edinburgh artist John Kay depicts him in his usual white linen clothes. He considered fresh air important to health and applied to build a house at the top of Arthur's Seat, 'to experience the utmost degree of cold that the climate in Edinburgh had to offer'.

Graham gradually became more and more eccentric. He gave public demonstrations of his 'earth bath', decided he was a messenger from heaven and called himself 'The Servant of the Lord, O.W.L.' (Oh! Wonderful Love!), and in 1792 he fasted for fifteen days and wore cut-turfs for clothing. Eventually he had to be put under restraint in his own house. For all his obsessions with health, he died suddenly from a ruptured blood vessel in a house in Buccleuch Street, in 1794, at the age of forty-nine.

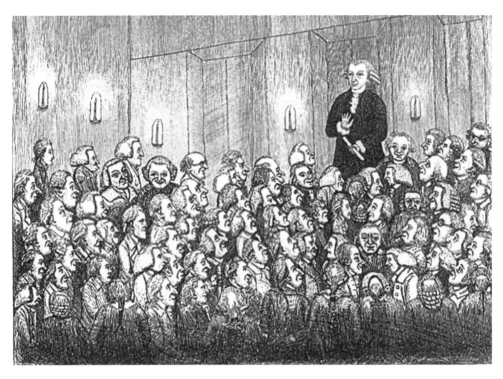

Above: James Graham lecturing.

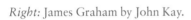

Right: James Graham by John Kay.

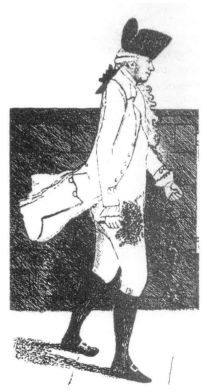

INNOCENT ART OF COCKING

Cockfighting was introduced into Edinburgh by William Mauchrie, a teacher of fencing and cockfighting in Edinburgh, in the first years of the eighteenth century. Mauchrie published an *Essay on the Innocent and Royal Recreation and Art of Cocking* in 1705, in which he noted that he had 'a special veneration and esteem for those gentlemen, about Edinburgh, who have propagated and established the Royal recreation and innocent pastime of cocking to which they have erected a cockpit on the Links of Leith'. Admission was 10*d* for a ringside seat, 7*d* for the second row and 4*d* for the back row.

Edinburgh Magistrates banned cockfighting on the streets in 1704 as a result of the 'tumults it excited and the cruel extent to which its practice had been carried'.

Despite this ban, cockfighting continued in Edinburgh well into the nineteenth century. Regular cockfights or 'mains', as they were technically termed, were held in a cockpit in the Grassmarket and there was a cockpit on Leith Sands in 1804.

John Kay, the Edinburgh artist, wrote in 1785 that he found it 'surprising that noblemen and gentlemen, in the prosecution of this barbarous sport, demean themselves so far as to associate with the very lowest characters of society'.

This 'school of gambling and cruelty' was finally outlawed in the nineteenth century and the last cockfight in Edinburgh was probably in 1869 when a Leith man was fined for participating.

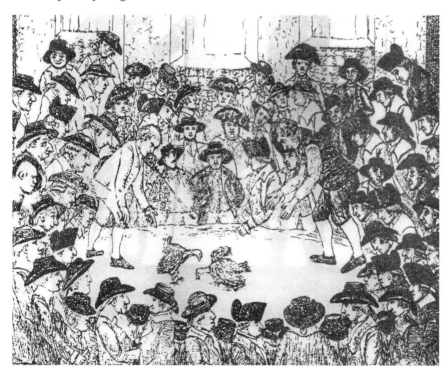

A cockfight.

THE ARTHUR'S SEAT COFFINS

In 1836, five Edinburgh boys were hunting rabbits on Arthur's Seat when they stumbled upon seventeen miniature coffins carefully arranged in a three-tiered stack and concealed beneath thin slabs of slate. The tiny coffins contained intricately carved miniature figures and had lain undisturbed for many years. The figures were expertly carved human effigies each dressed in their own unique clothing, with painted black boots and distorted facial features.

In recent times experts have tried to explain exactly when and why the coffins were made and who put them there. The theories over the years have differed widely. Some cite witchcraft as a possibility, while others have suggested that they were perhaps buried by sailors in a superstitious attempt to ward off death. Another widely held belief is that each of the figures were intended to commemorate the victims of the infamous serial killers Burke and Hare. However, all of the figures are dressed in male clothing, while twelve of Burke and Hare's victims were female.

The coffins and their contents remain an enduring mystery. They were held by a private collector where they remained until being passed over to the Museum of Scotland in 1901. The eight surviving coffins and their contents can be seen at the museum on Chambers Street.

The Arthur's Seat coffins.

ST ANTHONY'S CHAPEL

The picturesque ruin of St Anthony's chapel stands on a flat outcrop of rock, overlooking St Margaret's Loch, on the northern side of Arthur's Seat in Edinburgh.

The chapel was built in the fifteenth century and is recorded as having been repaired in 1426. The last record of a chaplain is in 1581. The chapel was originally a simple slate-capped building with a 40-foot-high tower, and appears in a view of the city as early as 1544. It remains an enigma, however, for neither the date of its construction, nor its purpose, is known.

There is a clear view of the chapel from Leith and the Firth of Forth, and it is possible that a light was hung in the tower to guide ships so that they could acknowledge the saint. There was also possibly a connection between the chapel and the Knights Hospitallers of St Anthony in Leith. St Anthony was born in AD 250 and founded the first monastery in history. His relics were associated with cures for the painful skin disease erysipelas, which was known as St Anthony's Fire. This disease was a serious problem in Edinburgh in the fifteenth century and a hospital was established in Leith in 1430 for its treatment. Another tale says that the chapel was founded for reasons connected with St Anthony's Well, a spring which rises on the slopes immediately below the chapel.

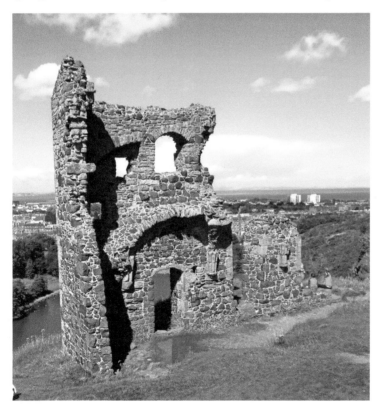

St Anthony's chapel.

St Anthony's Well.

JOHN KNOX'S GRAVE

John Knox (*c*. 1514–72), the noted Scottish religious reformer, is commemorated by a statue on the frontage of St Giles Kirk on the High Street. However, his last resting place under parking space No. 23 on Parliament Square at the rear of St Giles is somewhat less exalted.

Knox was originally interred in the old graveyard of St Giles Kirk. This was redeveloped in 1623 as a forecourt to the Parliament House, which housed the pre-Union Parliament of Scotland.

A commemorative stone that marked Knox's grave was moved inside St Giles many years ago and the site remained unmarked until recently, when a new inscribed stone plaque was added. The inscription reads: 'The above stone marks the approximate site of the burial in St Giles graveyard of John Knox the great Scottish Divine who died 24 Nov 1572.'

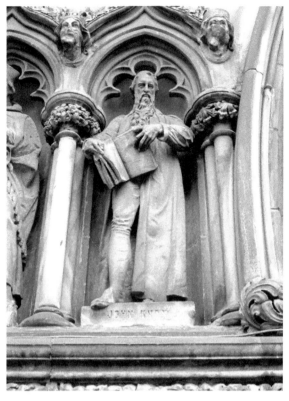

Top right: Original grave marker.

Left: Statue of John Knox on frontage of St Giles.

Below: Site of John Knox's grave.

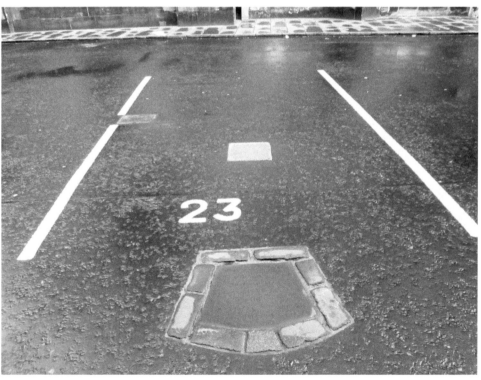

HEAVE AWA' LADS

Reports on the Old Town of Edinburgh in the 1840s, documented that the area had the most unsanitary living conditions of any other city in Britain. It was reckoned that 'overcrowding in the Blackfriars area was four times greater than in prison cells in this period'. The *Edinburgh News* went so far as to describe Old Town houses as 'chambers of death'. In 1850, it was noted at the Reform Association that 'the unclean heart of Edinburgh would not be gutted out until it was planted all around with new houses'.

This was brought into sharp public relief on 24 November 1861 when a tenement at Paisley Close, tumbled to the ground, killing thirty-five people. The building was a sixteenth-century timber house covered by a more modern stone front and it was estimated that at least 100 people occupied the property.

Prior to the collapse, the occupant of one of the ground-floor shops in the building had noticed a crack in the wall and movement in the roof. A temporary prop was inserted and, after examining the upper floors of the house, a builder concluded that the fault was minor and no further action was taken.

There were a number of remarkable escapes from the rubble of the building. One person was carried down by the falling wall and deposited on the pavement on the opposite side of the street with only slight bruises. Just before the accident, a police sergeant was passing the building when his attention was attracted on the other side of the street and he crossed over just in time to escape the collapse.

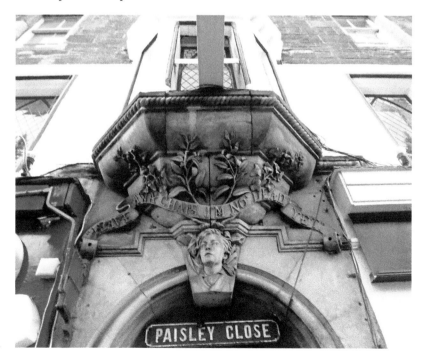

Memorial at
Paisley Close.

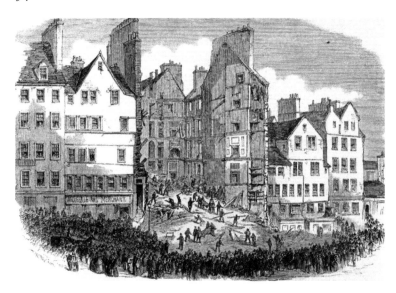

Building collapse
at Paisley Close.

One young boy was pulled out of the rubble after around five hours of digging. He encouraged the efforts being made to release him by calling out: 'Heave away, my lads; I'm no deid yet.' It is an event commemorated above the entrance to the rebuilt building by an inscription and sculpture of the boy's face.

Newspaper reports of the time noted that:

The catastrophe created an immense sensation in Edinburgh, and the terrible event was referred to in all the pulpits. Never before in the history of the city has there been such a prodigious loss of life from a domestic accident. The lack of municipal supervision which the disaster indicates is the apparent cause of the calamity. Mr Charles Dickens, now in Edinburgh, has been actively interesting himself in the unfortunate matter.

THE SIX FOOT HIGH CLUB

The Six Foot High Club was established in Edinburgh in 1826 and, as the name suggests, membership was restricted to people of 6 feet or more. The club was very particular that every candidate for admission was the required height in his stocking soles. For this purpose, two of the managing committee acted as 'Grand Measurers'. Their main duty was to certify the height of every candidate for admission into the club. In order to prevent all disputes, a standard measure was erected in the clubroom, with a cross bar 6 feet from the ground and only adjustable upwards. If a sheet of writing paper could be placed between the head of the aspirant for the honour of being a member and the cross bar, he was declared 'wanting'. The number of members was restricted to 135 and generally they were residents in or near Edinburgh.

Six Foot High Club athletics.

The club activities centred on the practice and encouragement of athletics and gymnastics at a gymnasium in East Thistle Street and a training ground in Malta Terrace. It seems that club members had a particular interest in throwing the sledgehammer – an exercise 'particularly well calculated for bringing into play all the muscles of the body'.

Members of the club acted as guard of honour to the Rt Hon the Earl of Errol, Hereditary Lord High Constable of Scotland. The club motto was *Scientia viribus juncta*, which refers to the relationship between strength and skill.

The dress uniform of the club was 'the finest dark green cloth coat, double breasted with special buttons and a velvet collar – on special occasions, a tile hat was worn'.

The club also seems to have had a literary interest. Exceptions to the 6-foot rule were made to grant honorary membership to Sir Walter Scott, who was the club umpire, and James Hogg, who was the club's poet laureate.

THE MOUND

The Mound has long been a focal point for outdoor performance in Edinburgh. During the first half of the nineteenth century it was known as 'Geordie Boyd's Mud Brig', and was a wide, unkempt space, described by Lord Cockburn as a 'receptacle of all things disreputable'.

On holidays and Saturdays, the site now occupied by the National Gallery of Scotland became the 'resort of low class traders and entertainers', who set up roulette tables, shooting galleries and coconut shies. Turkey Rhubarb (a guaranteed cure-all patent medicine), religious tracts, small dogs, spectacles and linnets in paper bags were among the goods on sale. Temporary shows were also allowed to use the site. These included Wombwell's Menagerie and, in September 1820, a six-foot-high, 310-stone ox was exhibited to the public at the charge of 1s for ladies and gentlemen, and 6d for the working class.

A more permanent show was the Rotunda, built in 1823 to house 'Marshall's Panorama' in which dioramas were shown. Dioramas were an early type of cinema involving a superior form of magic lantern display.

In its heyday, the Rotunda offered six one-hour performances a day with commentary and musical accompaniment. The first public show consisted of a 'Grand Historical Panorama of the Battle of Waterloo', with music provided by a full military band. The most popular diorama displays, drawing the largest audiences, were exhibitions of slides of ghostly apparitions and demons – the nineteenth-century equivalent of horror films.

Educational 'documentary' displays, such as slides illustrating the movement of the planets and scenes of European cities with appropriate music and commentaries, were also a major attraction.

The Rotunda was demolished in 1850 to make way for the construction of the National Gallery.

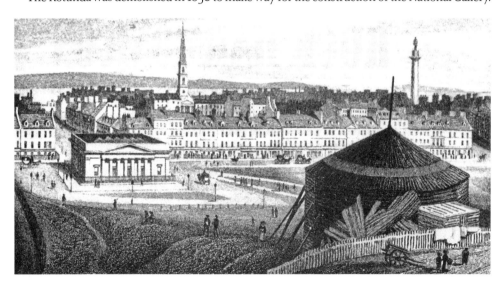

The Mound.

THE GRAND EDINBURGH FIRE BALLOON

Edinburgh's James 'Balloon' Tytler was a spectacular Jack-of-all-trades – surgeon, writer, publisher, composer, and poet – but his claim to fame is rooted firmly in the day he made aviation history. The 'Grand Edinburgh Fire Balloon', which he invented, created a great deal of excitement in 1784 and ultimately resulted in Britain's first manned aerial ascent.

Tytler was an eccentric and luckless character, described by Burns as an 'obscure, tippling though extraordinary body', and both his epic flight and his other great achievement – the eight years he spent compiling the ten-volume second edition of the Encyclopaedia Britannica – are both largely overlooked.

He worked as a surgeon and an apothecary, wrote numerous books and articles, published periodicals and a newspaper, invented a printing machine, a process for bleaching linen, and composed songs, poems and tunes for the bagpipes. None of these activities made much money – he was paid a pittance of 16s a week for writing the Encyclopaedia, although a number of them made money for others, and he was outlawed as a debtor at least twice.

The successful flights of the Montgolfier brothers in France in 1783 fired Tytler with an enthusiasm for ballooning, and in June 1784 he exhibited the 'Grand Edinburgh Fire Balloon' in the uncompleted dome of Robert Adam's Register House. The 'Fire Balloon' was described as barrel-shaped, was 40 feet high, 30 feet wide and was powered by heating the air in the balloon with a stove.

Weather conditions prevented the first attempt at a flight early in August, but on 27 August 1784, in Comely Gardens, an open area north-east of Holyrood in Edinburgh, Tytler tried again. Wearing only a cork jacket for protection, he seated himself in a small wicker packing case tied to the base of the balloon. When the ropes holding the balloon were released it soared to 350 feet, travelled half a mile, and landed in Restalrig village. Tytler found the flight 'most agreeable with no giddiness' and he 'amused himself by looking at the spectators below'.

This first flight was made in front of a small number of people early in the morning, but news of his success ensured that the next appearance of the 'Fire Balloon' four days later was a major public event. A large paying audience gathered in the Comely Gardens, and the slopes of Arthur's Seat and Calton Hill were crowded with people eager to witness this historic occasion. At 2 p.m., the balloon was inflated for half an hour and, with Tytler again in the basket, rose to 100 feet, sailed over the pavilion and descended gradually on the other side. This 'leap' was not particularly remarkable but the spectators were delighted. However, all subsequent exhibitions of the 'Grand Edinburgh Fire Balloon' were disasters. One newspaper considered that enough time had been 'trifled away on this misshapen smoke-bag', and in the excitement of the flamboyant Vincenzo Lunardi's very successful balloon ascents in 1785 the unfortunate James 'Balloon' Tytler was forgotten.

In 1792, Tytler fled Edinburgh for Ireland, after being arrested for producing anti-government pamphlets, and three years later he moved to Salem, Massachusetts. There, on a stormy night in January 1804, the first British aviator drowned while walking home.

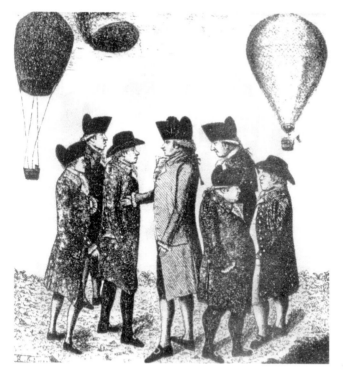

James Tytler, third from left.

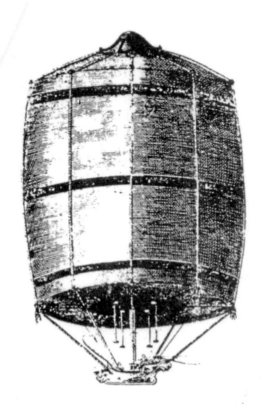

The Grand Edinburgh Fire
Balloon.

THE WAUCHOPE MAUSOLEUM

The Wauchope Mausoleum, a little single-storey tomb house, is hidden away in the back gardens of Niddrie House Drive. It is the last remaining part of the grand Niddrie-Marischal House and a reminder of the historic associations of the area with the Wauchope family.

The Wauchope family were the lairds of Niddrie-Marischal in Edinburgh for 600 years from the late fourteenth century (the Wauchopes were hereditary Bailies to the Keiths, Earls Marischal and Marischal deputies in Midlothian). Gilbert Wauchope, from a branch of the Aberdeenshire family, is recorded as being granted the lands of Niddrie near Craigmillar Castle by Robert III in the latter part of the fourteenth century. By the sixteenth century, the family had a castle or tower house large enough to accommodate '100 strangers' and, in 1502, had founded a chapel.

In 1588, Archibald Wauchope, along with others, was accused of the murder of four men. Imprisoned in Edinburgh's Tolbooth, he escaped out of a window. The following year he killed again. He was also involved with the Earl of Bothwell in an unsuccessful insurrection against James VI in 1589. In 1597, he broke his neck trying to escape out of a window, when he was cornered in a house in Sclater's Close in Edinburgh. Archibald's estate was forfeited and his castle burned down 'by a mob out of revenge for his many wrongs'.

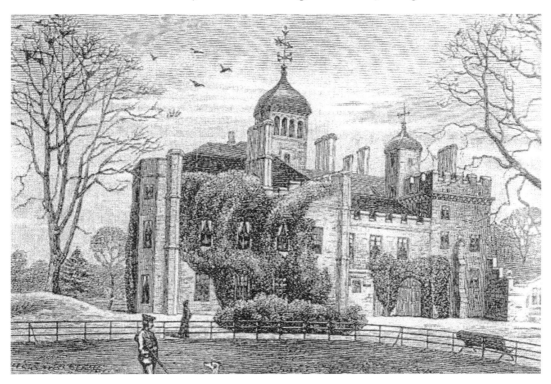

Niddrie-Marischal House.

In 1603, Francis Wauchope, Archibald's eldest lawful son, was 'restorit and rehabilitat ... to his haill landis pertaining to his said father'. By then, the estate had been sold on, but Francis resolved this by marrying the new owner's heiress. He began to build what would be the new Niddrie House, which was completed by his son John in the 1630s. A good part of the wealth needed to pay off family debts and build such a grand house came from the coal seams that spread under Niddrie and the adjoining estates.

With the accession of James VII, it appears that the Wauchopes were among those who began to worship according to 'Roman rites'. In 1687, the Edinburgh mob sacked the chapel royal at Holyrood and drove out the Jesuits. The mob then set off to do the same at Traquair and on its way burned out the Wauchope chapel.

In 1735, Andrew Wauchope erected the tomb house over the grave of William Wauchope, who died in 1587. Some carved stones, probably from the earlier chapel, were inserted in the wall that encloses the front. The raised grave slab in the tomb house is decorated with a small shield below two five-pointed stars. Around the edge of the slab's surface runs the inscription:

HEAR. LYIS. ANE. HONORABIL MAN. WILLIAM. WAVCHOP. OF. NIDRE-MERSCHIL
QVHA. DEC [EA] SI [T] YE. VI. DA. FEB RAVR. 1587

The last of the Wauchopes at Niddrie was the childless widow of a major general who had died fighting in the Boer War in 1899. On her death in 1943, the estate was put up for sale. On Hogmanay 1959, the *Evening News* headline announced 'Edinburgh Mansion House Gutted by a Spectacular Fire.'

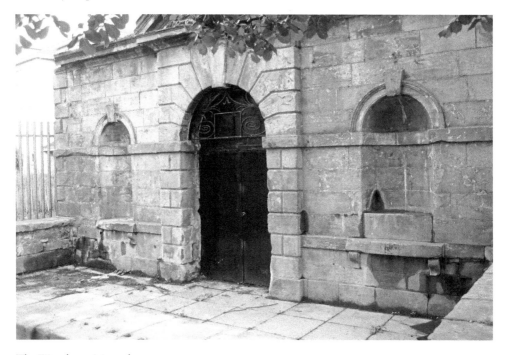

The Wauchope Mausoleum.

THE CRAIGENTINNY MARBLES

The Craigentinny Marbles is the name normally applied to the huge mausoleum structure with ornate marble sculptures of Biblical scenes that stands strangely amid the suburban houses of Craigentinny Crescent, just off Portobello Road in Edinburgh. The name is derived from the two sculptured panels that embellish the monument. David Rhind designed the monument and the eminent Victorian sculptor, Alfred Gatley carved the bas-relief marbles that depict *The Overthrow of Pharaoh* and *The Song of Miriam*. The panels were described in 1867 when they were fixed to the monument as, 'the most remarkable pieces of sculpture executed during this century' and 'attracted artists from all parts to view them'.

The monument is more accurately called the Miller Mausoleum, as it marks the last resting place of William Henry Miller. Miller was at one time MP for Newcastle-under-Lyme and was a renowned collector of books. He was known as 'Measure Miller', from his habit of carrying around a ruler to measure the exact size of copies of books before deciding if it would enhance his collection.

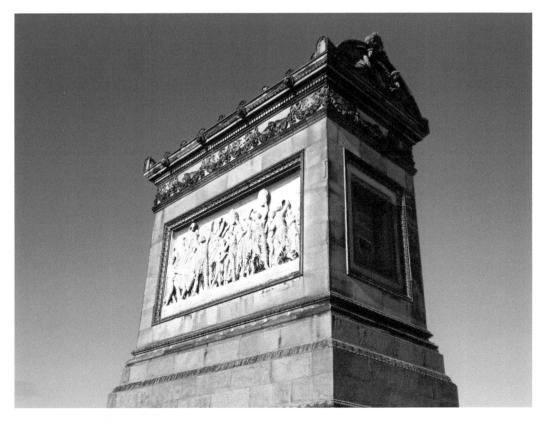

The Craigentinny Marbles.

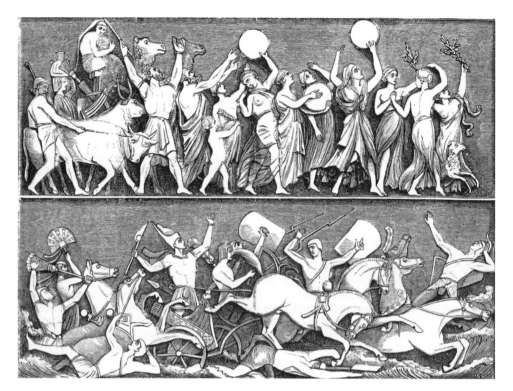

Plaques from the Craigentinny Marbles.

Miller died in 1848, at the age of sixty, after a short illness at his estate at Craigentinny. He was not buried until six weeks after his death and this resulted in speculation about the method of his internment. Events were reported in the newspapers under the heading 'Singular Internment'. It was reported that eighty labourers had been hired to excavate a stone lined pit 40 feet deep for his grave and that a large stone slab was positioned at the bottom of the grave to secure the coffin.

Rumours soon developed around the reason for the elaborate burial arrangements. It was said that Miller was 'notable for his spare figure, thin treble voice and total absence of beard', and it was suggested that Miller, who had never married, had been an adopted female orphan who had masqueraded as a man all his life.

DR KNOX ESCAPES THE EDINBURGH MOB

Up the close and doun the stair,
But and ben wi' Burke and Hare.
Burke's the butcher, Hare's the thief,
Knox the boy that buys the beef.

Before the Anatomy Act of 1832, which expanded the legal supply of medical cadavers, there were insufficient bodies available for anatomical dissections in the medical schools. Executed criminals were the main source, but this had been reduced due to a decrease in executions in the early nineteenth century.

The medical schools came to rely on bodies that had been acquired by nefarious means and grave robbing by 'resurrectionists' became one of the main sources. This gave rise to particular public fear and watchtowers were set up in graveyards so that relatives could watch over the graves of their dearly departed for such time that the bodies would no longer be of use for dissection.

Edinburgh's notorious Burke and Hare saw the potential profit in this, but rather than going to the hard work of grave robbing, they simply murdered their victims and sold the bodies to the Edinburgh Medical School for dissection. Over a period of a few months in 1828 they were responsible for the murders of seventeen victims – crimes that shocked and terrified Edinburgh.

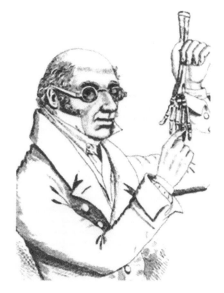

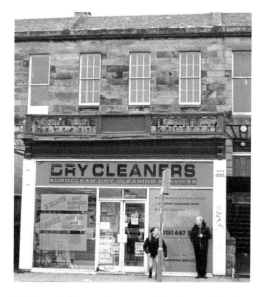

Dr Robert Knox.

Dr Knox's former house on Newington Road.

William Burke was publicly hanged on the morning of 28 January 1829 in front of a crowd estimated at between 20,000 and 25,000, and on the following day his body was dissected in the anatomy theatre of the University's Old College. Hare, who had been granted immunity from prosecution by giving evidence against Burke, was released in February 1829 and assisted in leaving Edinburgh.

Burke and Hare's victims had been dissected by Dr Robert Knox, one of the greatest anatomists of his day, who regularly drew a class of above 400 pupils. Knox was officially cleared of any complicity in the murders; he had no direct contact with Burke and Hare and claimed that he had no reason to suspect foul play. However, the Edinburgh mob had a different view of this and held him accountable nonetheless.

This came to a head on 12 February 1829. Early in the day, a mob marched up the Bridges to Newington carrying an effigy of the doctor that was hung by the neck from a tree. It was later torn to pieces by the frenzied crowd. At the time, the houses in Newington Road had no shops in front, and the garden of the doctor's house and the adjacent street were packed with people screaming that Knox was a murderer. The police, with the assistance of the city guard, eventually managed to disperse the mob.

Later in the evening the crowds reassembled in many parts of Edinburgh, and around 7 o'clock they swarmed into Newington. This time the mob was in an ugly mood. The doctor's house was attacked and every pane of glass in the building was smashed.

The situation was now serious and Dr Knox knew that he was in some danger. Fortunately he was not well known to the ordinary people of Edinburgh and with a military cloak concealing a sword, pistols and a highland dirk Dr Knox left the house by the back door and slipped through the mob. Knox moved to the village of Lauder in the Scottish Borders, but continued to lecture into the 1840s. Eventually he moved to London where, from 1856, he worked as an anatomist at the Brompton Hospital and had a medical practice in Hackney until his death in 1862

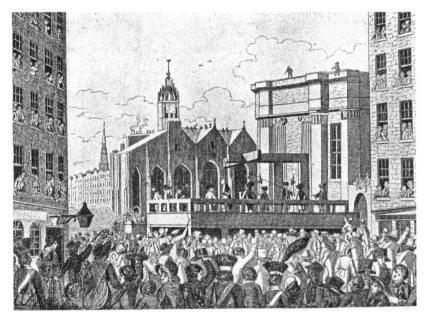

The execution of Burke.

SCOTTISH TROGLODYTES – GILMERTON COVE

Drum Street in Gilmerton is home to the 'subterranean chambers of a remarkable cave'. The following account was given by the Revd Thomas Whyte, parish minister of Liberton, in 1792:

> Here is a famous cave dug out of rock by one George Paterson, a smith. It was finished in 1724 after five years hard labour as appears from the inscription on one of the chimney-heads. In this cave are several apartments, several beds, a spacious table with a large punch-bowl all cut out of the rock in the nicest manner. Here there was a forge with a well and washing-house. Here there were several windows which communicated light from above. The author of this extraordinary piece of workmanship after he had finished it, lived in it for a long time with his wife and family and prosecuted his business as a smith. He died in it about the year 1735. He was a feuar of feodary and consequently the cave he formed and embellished so much and the garden above it was his own property, and his posterity enjoyed it for some time after his decease. His cave for many years was deemed as a great curiosity and visited by all people of fashion.

Paterson is also reported as being 'forgiven the yearly duty and public burdens, on account of the extraordinary labour he had incurred in making himself a home'.

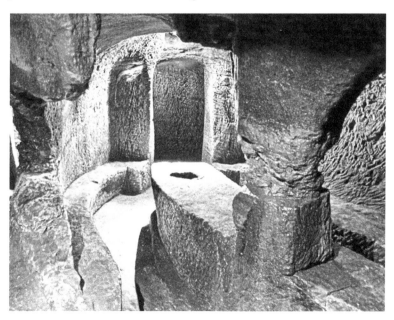

Gilmerton Cove.

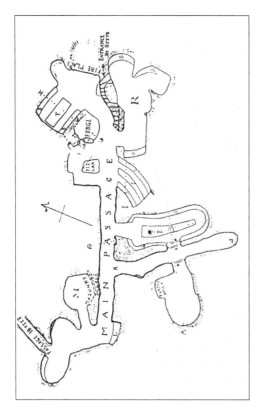

Plan of Gilmerton Cove.

The cave is around 10 feet below the surface and is reached by a flight of twelve steps which lead into a 40-foot-long passage with an unusual series of rooms and passages on each side. Immediately to the right, at the foot of the stairs, is a recess like a blacksmith's forge, with an aperture through which bellows may have passed, and behind it a room with a fireplace, table and benches all carved from stone.

The rooms on the left of the main passage are more elaborate and most contain furnishings carved out of the sandstone. The first large room has a number of recesses with stone plinths that may have been used as beds. The next smaller space is almost entirely filled by a narrow stone table with benches on either side.

The next room is larger – around 15 feet long by 5 feet wide – and its ceiling is supported by a stone pillar. This room is popularly known as the 'drinking parlour' and has a 10-foot-long curving table at its centre with seats around the edge. The base of the table is cut inwards with a 3-inch-wide stone ledge left as a footrest, but the most unusual feature of the table is the 13-by 8-inch bowl-shaped cavity that has been carefully cut into the surface of the table. Two steps lead from the 'drinking parlour' to a 12-foot-long, narrow side passage that ends in a mass of masonry and which was probably another entrance to the cave. There is a further large room on the other side of this secondary passage. The main parts of the cave have a ceiling height of around 6 feet.

At its far end, the main passage curves to the right and there is an entrance to a narrow tunnel around 3 feet high. It is speculated that this tunnel at one time provided a link to Craigmillar Castle, which is some distance away.

Alexander Pennicuik, the 'burgess bard of Edinburgh', provided the following inscription, which is variously detailed as being carved in stone over the entrance and on a fireplace in the cave:

> Upon the earth thrives villainy and woe,
> But happiness and I do dwell below,
> My hands hewed out this rock into a cell
> Wherein from din of life I safely dwell.
> On Jacob's pillow nightly lies my head,
> My house when living and my grave when dead
> Inscribe upon it when I'm dead and gone
> I lived and died within my mother's womb.

There is now no sign of this inscription, but over the fireplace in the room behind the forge is a neatly carved oblong recess that may have contained the inscription on an inserted panel.

In 1897, F. R. Coles, assistant keeper of the National Museum of Antiquities of Scotland, investigated the cave and cast considerable doubt on whether Paterson had constructed it. Coles considered that 'the method of cutting the stone pointed to an origin much more remote than the eighteenth century and the substantial work involved in excavating the cave could not have been carried out by one man in five years'.

Coles also noted a number of narrow holes in the ceiling of the cave around the 'parlour'. He first considered that these were for ventilation, additional to the larger skylight openings in the roof; however, his alternative theory was that they were for 'bringing liquor down in the cave around the principal table at which, with its "punch-bowl", carousals or secret political or Masonic meetings were held'. It could be that Gilmerton Cove has a darker and more distant history than is popularly believed, although it is likely that the full story of the cove will never be known.

LEITH RACES

For almost 200 years – 1620–1816 – the main venue for horse racing in Scotland was a long stretch of beach east of Leith Harbour, on the site now occupied by the docks.

The Leith Race week was normally held at the end of July or the beginning of August, and was the sporting event of the year in Scotland. The races attracted great crowds of people from all over the country, and kept the city in a 'state of feverish excitation and caused a general suspension of work and business'.

As the race week was run by the town council, a uniformed city officer marched to the races every morning, 'bearing aloft at the end of a long pole the gaily ornamented city purse'. The race-goers walked with him down Leith Walk so that he 'disappeared amidst the moving myriads, until only the purse at the end of the pole revealed his presence'.

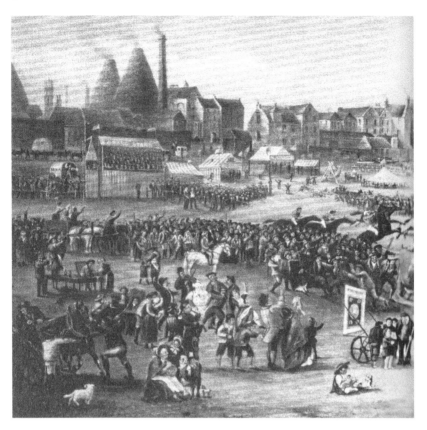

Leith Races.

Great care was taken to have the sands measured off and in good order for the horses, and proclamations were issued prohibiting digging for bait until the races were over.

Prizes included the City of Edinburgh purse of £50, His Majesty's purse of 100 guineas and the Ladies Subscription of 50 guineas. On the last day of the meeting, there was a purse for the horses beaten in the earlier part of the week.

The racing seems to have been subsidiary to other activities on the sands. These included wheels of fortune and refreshment at the 'vast lines of drinking booths which stretched along the shore'. For an entire week, the town was 'one continued scene of racing, drinking and fighting'.

The race meeting was usually concluded by the 'general demolition of the stalls and booths and a fighting match among those that were able to keep their legs, a riotous brawl being maintained by the returning crowds along the entire length of Leith Walk'.

In 1816, the horse racing was transferred to Musselburgh Links, as the smooth turf provided an improved track. Attempts were later made to re-establish the Leith Races, but the council refused permission due to the increasing pressure of public opinion against the 'drunkenness and excesses' associated with the event.

ST BERNARD'S WELL

According to tradition, St Bernard's Well near Stockbridge in Edinburgh was rediscovered by three Heriot's schoolboys while fishing in the Water of Leith in 1760. Legend has it that it was originally discovered by St Bernard of Clairvaux, the founder of the Cistercian Order, in the twelfth century. After being poorly received at court and suffering from a sickness, he went to live in a cave near the Water of Leith. There, he was attracted to the spring by the birds that visited it and he drank its healing waters until his strength returned.

In September 1760, the mineral spring was covered by a small well house. 'Claudero' (James Wilson), the contemporary poet, composed a tribute for the occasion:

This water so healthful near Edinburgh doth rise which not only Bath but Moffat outvies. It cleans the intestines and an appetite gives while morbfic matters it quite away drives.

Chemical analysis revealed that the water was similar to the sulphur springs at Harrogate in Yorkshire. The mineral well soon became a popular resort for those afflicted by the fad for 'taking the waters'. By 1764, the well was so great an attraction that accommodation in the Stockbridge area was at a premium during the summer season. It seems that habitual drinkers of the waters must have had cast-iron constitutions, for one later visitor likened the flavour of the water to 'the washings of foul gun barrels'.

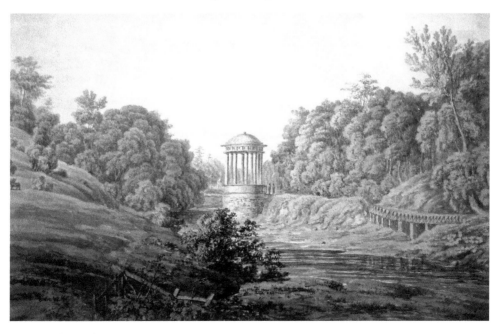

St Bernard's Well.

In August 1788 the well was bought by Lord Gardenstone, who claimed he had derived great benefit from drinking the water and, in 1789, the present construction – a circular Roman Temple – was commissioned by him. This elegant architectural structure in the form of a Doric rotunda is inspired by the Temple of Vesta at Tivoli in Italy. Under the lead dome there is a marble statue of Hygieia, Goddess of Health.

In 1885, the well and grounds were purchased by the publishers Thomas Nelson & Sons. After restoration, it was left to the City of Edinburgh. The pump room was refurbished in a lavish Victorian style. The interior was designed like a celestial vault, which sparkled with sequin-like stars when sunlight struck through the stained-glass windows. The white marble pedestal is inscribed 'BIBENDO VALEBIS' (By Drinking You Will Be Well).

Remarkable claims continued to be made for its medicinal properties, ranging from the efficacy of a regular morning glass as a tonic for the system to a complete cure-all for rheumatism and arthritis. The temple then resembled a continental cafe with 'little tables where regulars chatted with friends'. Aerated water from the well was even bottled and marketed for a short while. The well remained popular until its closure in 1940.

GOLF AT BRUNTSFIELD LINKS

Golf, already well known in Scotland around the middle of the fifteenth century, was so popular that it was at one time prohibited because it interfered with the practice of archery. Bruntsfield Links was originally an area of common grazing ground where victims of the plague were banished.

It was also Edinburgh's earliest course for the pursuit of the Royal and Ancient game. Two pioneering clubs, the Royal Burgess Golfing Society and the Honourable Company of Edinburgh Golfers, were established at Bruntsfield in the mid-eighteenth century. Golf was so popular in Edinburgh at this time that the town council sponsored a trophy – a silver club – as an annual prize for members of the Honourable Company.

If among today's golfing enthusiasts there are many for whom the game is an obsession, it is unlikely that their condition is as acute as was that of one of Bruntsfield's eighteenth-century players. A well-known figure around Edinburgh, Alexander McKellar owned a tavern in the city's New Town. He was a very keen golfer and it is said that each day after breakfast he set out for Bruntsfield Links, where he would spend the whole day, and by all accounts much of the evening, playing his favourite game by the light of a lantern. The running of the family business was left to his wife, who was often forced to send her husband's meals up to the Links.

Perhaps, not unnaturally, McKellar's wife developed an almost fanatical dislike for golf and indeed saw golfers as unwelcome customers in her tavern. McKellar apparently never achieved any great prowess at the game, despite the long hours spent on the course. Nevertheless, until his death in 1813, he proudly retained the title of 'Cock of the Green'.

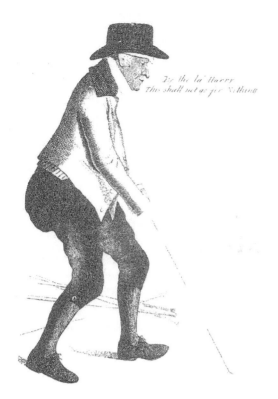
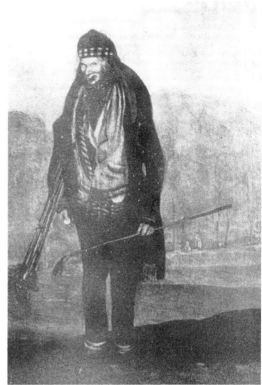

Alexander McKellar, the 'Cock of the Green'. Daft Willie Gunn.

 If Alexander McKellar was Bruntsfield's most enthusiastic player, the most eccentric and odd character was Daft Willie Gunn, a regular caddie at the course during the early part of the nineteenth century. Willie's notoriety and reputation for daftness resulted from his habit of wearing all the clothes he owned at the same time. He would be seen in numerous layers of coats, hats, shirts and trousers whether it was summer or winter. To enable him to wear three or four jackets and coats, he would cut of the sleeves of all but the outer one. Apart from his unusual dressing habits, Willie would only ever eat bread and milk, never cooking hot food nor having a fire in his lodgings, even in the coldest weather.

 Bruntsfield Links remains as a pitch and putt course and is possibly the only free golf course in the world.

THE EDINBURGH ROYAL ZOOLOGICAL GARDENS

Edinburgh's first Royal Zoological Gardens opened to the public in August 1840. They occupied 6 acres in East Claremont Street and were 'designed for securing safety as well as the favourable display of animals for the satisfaction of the spectators'.

The 1842 guide to the Royal Zoological Gardens describes them as a 'valuable institution of national importance forming an extensive and varied collection'. One report noted that the elephant exemplified the 'great utility of the Zoological Gardens in which the animal could be seen in living grandeur, it being so difficult to convey an adequate idea of this stupendous beast in words or even by drawings'. The specimen in the collection was an imposing eight-year-old male and visitors were particularly encouraged to admire 'that exquisite piece of mechanism, its lithe proboscis'.

The bear enclosure was a deep stone-lined pit, with a pole in the centre by which 'Bruin would ascent to collect titbits offered by visitors'. The most 'striking and magnificent' exhibit was the 'wonderful and unique' skeleton of a whale which was 'astonishing in its ponderous proportions'. It measured 84 feet long and was the only perfect whale skeleton of its kind in existence. This 'stupendous production of nature' had been found floating in

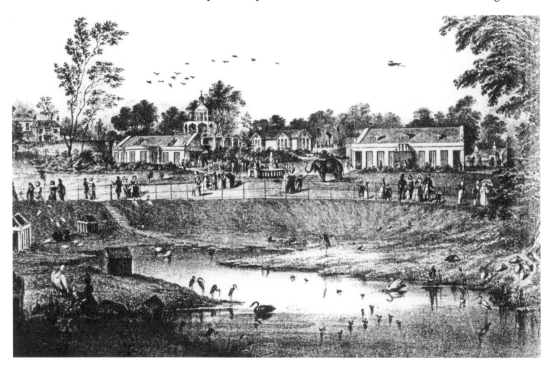

The Zoological Gardens.

THE SCOTTISH NATIONAL EXHIBITION

The Scottish National Exhibition was held in Saughton Park, Edinburgh, in 1908. The aims of the exhibition were to exemplify all that was best in art, science, literature and industry from 'His Majesty's Dominions'. The North British Railway built a new station on the main line adjoining the exhibition, to bring the many thousands of visitors from Edinburgh's Waverley station.

The Palace of Industries covered an area of 100,000 square feet, with an ornamental 125-feet-tall tower at each end. The exhibits were of an 'exceptionally high class', comprising the following sections: Scottish, Irish, English, Dutch, Japanese, Italian and Canadian, with sections devoted to education, transport and women's work. The machinery hall featured printing, lithography, shipping, mining, electric, gas, steam, water, sewage disposal, baking and confectionery.

The Fine Art Galleries housed the best of Scottish art and a collection of 'rare and historic exhibits that must appeal to every Scotsman, and should prove intensely interesting to visitors from all parts of the world'. One gallery was set aside for 'one of the most complete collections of rare and valuable relics appertaining to the Highlands and Islands of Scotland ever brought together'. Among the exhibits were regimental colours, old clan tartans, Gaelic manuscripts, claymores and locks of Bonnie Prince Charlie's hair.

The Scottish National Exhibition.

The Music and Conference Hall was 'a most striking building, circular in shape, with prettily decorated outside walls and four ornamental towers'. It included 'a striking novelty in the shape of a fairy fountain which sprays water from hundreds of varying jets and with limelight shed upon it from overhead at different angles produces a most beautiful scene, that in point of colour rivals the rainbow and a handsome organ with patent tubular pneumatic action and blowers'. The Winter Garden, a 'delightful place for large parties to enjoy the cup that cheers' (tea), can still be seen on Edinburgh's Balgreen Road.

CABLE TRAMS

A short section of the original tram rail and cable track at Waterloo Place is a surviving relic of the old system in central Edinburgh.

Edinburgh's 142-year affiliation with trams began in November 1871 when the Edinburgh Street Tramways Co. introduced a 3.5-mile horse-drawn line from Haymarket, via Princes Street and Leith Walk, to Bernard Street, Leith. This replaced an earlier coach service that had run along the same route – the only difference being the presence of guide rails that provided passengers with a noticeably smoother journey.

Over the next decade the popular tram network began to sprout into new districts such as Newington and Portobello, with further expansion significantly hindered by the notorious rough terrain in certain areas of the city. It seems that as many as five horses were required to tackle the formidable slopes of the New Town. In January 1888, this problem was cracked with the advent of the cable-hauled system, a method that was already in use in San Francisco – a city renowned for its steep elevations similar to Edinburgh. The

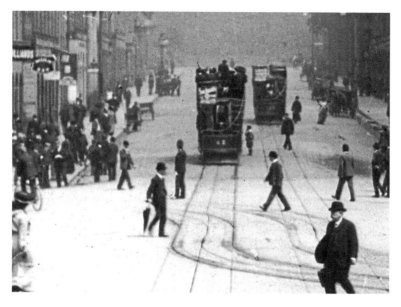

Cable tram track at Waterloo Place.

cables ran in a channel in the middle of the track and were steam-driven from four power stations. The tramcar employed a gripping mechanism that dropped into the channel and connected the vehicle to the running cable, hauling it along at a leisurely 12mph. The new technology enabled the tramcar to appear in areas of the city that had hitherto proved too difficult for horses to negotiate.

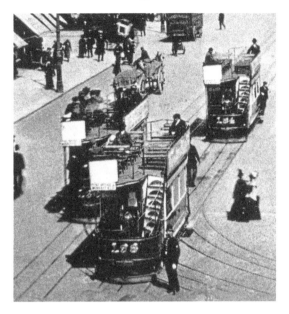

Cable trams on Princes Street.

Cable trams at Waterloo Place.

Pilrig Church, Leith

Site of the Pilrig Muddle.

In 1905, when the newly created Leith Corporation Tramways pioneered the use of electric traction, an anomaly appeared that would take nearly twenty years and the unification of two separate autonomous burghs to sort out. Since Edinburgh's system was predominantly cable run and Leith's electrified, passengers travelling either way along Leith Walk were forced to change vehicles at the Pilrig city boundary. The merger between the two burghs in 1920 formed the catalyst for the upgrade of the Edinburgh network to an electric system. Electric trams finally crossed the frontier on 20 June 1922 and the chaotic interchange known as 'the Pilrig Muddle' was eradicated. Edinburgh's last cable tram operated a year later on the Portobello line.

The final day of the electric trams fell on 16 November 1956. That evening, a grand procession of tramcars paraded from the Braid's terminus to Shrubhill depot in Leith, taking in much of the original 1871 route. At the Mound an enormous crowd gathered to bid an emotional farewell to a much cherished thread of the city's colourful fabric.

A CANINE CONNECTION – BUM THE DOG

The bronze statue of a dog named Bum is located at the King's Stables Road entrance to Princes Street Gardens. The statue was presented to Edinburgh by the city of San Diego, California.

Bum has a similar story to Greyfriars Bobby and the same iconic status in San Diego. An exchange of statues of the two dogs was seen as a way of marking the link between the two cities, which were twinned in 1978.

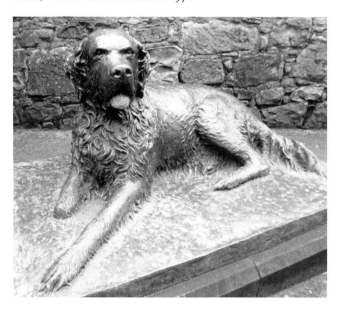

Statue of Bum.

The unveiling ceremony on 19 July 2008 was preceded by a parade of dogs through Princes Street Gardens, led by members of the Skye Terrier Association in Victorian costume. Statues of Bum and Greyfriars Bobby had previously been unveiled in 2007 in San Diego.

Bum's life was documented in a blend of fact and fantasy by James Edward Friend, a San Diego journalist. According to Friend, Bum was born in San Francisco in July 1886 to a stray. He was adopted by the men of a local fire station but soon proved too itinerant for a settled life. Someone began calling him 'Bum' and the name stuck. Legend has it that Bum then boarded a boat as a stowaway and disembarked in San Diego.

Bum had an independent nature and although many of the townspeople of San Diego would have gladly taken him home, he wasn't interested and preferred sleeping on the streets. This may have been due to that fact that he did very well on handouts of food at local restaurants and butchers' shops. One restaurant displayed a sign that read, 'Bum eats here'– a sound endorsement from the discerning Bum.

It seems that Bum also developed a taste for alcohol after hanging around bars and, during a fight with a bulldog on a rail track, the two dogs were hit by a train severing part of Bum's front right foot and killing the other dog.

In the years that followed, many of Friend's newspaper reports featured Bum, making the dog the unofficial mascot of San Diego where he was a much loved 'town dog'. So great was the public's affection for Bum, that an artist was commissioned to paint his portrait.

After San Diego passed a byelaw in 1891 requiring all dogs to be registered, the city council granted him a tag for life 'on the grounds that he did more to advertise the city than most of the newspapers'. His image was stamped on all dog licenses issued.

In 1894 Bum was injured again when his rear leg was fractured from a kick by a horse when he was visiting Magwood's Department Store. Mr Magwood paid for his medical

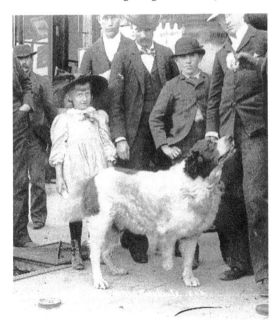 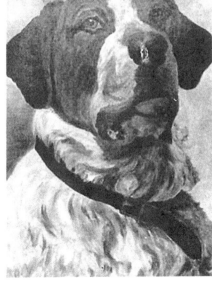

Bum receives a doughnut.　　　　　　　　　　Portrait of Bum.

treatment and readers of Friend's articles were told that they could stop by and visit Bum at Magwood's as he recuperated

By 1898, the free-roving town dog was having difficulty getting around because of arthritis. After Friend passed away, the Board of Supervisors ordered that Bum be retired to the County Hospital. He died there on November 19, 1898 and was buried in the grounds.

PRINCES STREET RAILWAY STATION

Princes Street railway station, also known as the 'Caley', stood at the west end of Edinburgh between 1870 and 1965. It was the largest train station in Scotland, occupying a vast stretch of the city centre from the north eastern tip of Rutland Street all the way to where the present-day Festival Square meets the Filmhouse cinema on Lothian Road.

The western-based Caledonian Railway first extended a line into Edinburgh in 1848, which saw the erection of a temporary wooden station on Lothian Road. The initial Lothian Road station existed until 1870 when the line was extended a little further north towards Princes Street; the shift in location forcing a name change. By the 1890s, with passenger levels rapidly increasing, the decision was taken by The Caledonian Railway to create a

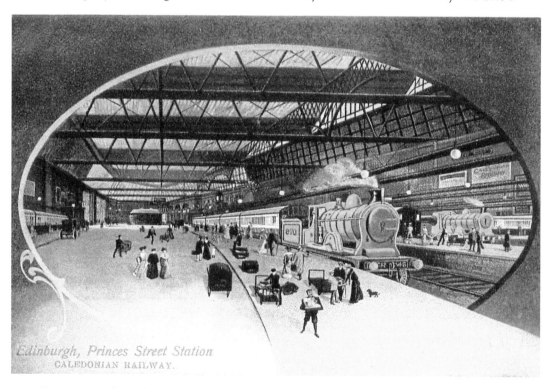

Edinburgh, Princes Street Station
CALEDONIAN RAILWAY.

The entrance of Caledonian station.

grand terminal for Edinburgh to rival Edinburgh Waverley. Boasting seven platforms, street level access and a colossal 850-foot-long roof, it was a formidable opponent to Edinburgh's other station.

As the turn of the nineteenth century approached, an influx of tourism, particularly among the upper classes, provoked many rail companies to cash in by providing convenient onsite accommodation for their passengers. In 1902, the North British Railway built the grand and luxurious North British Hotel at the east end of Princes Street. Its proposed construction in 1895 would have undoubtedly spurred those running the Caledonian line into action and on 21 December 1903, The Caledonian Hotel officially opened. The hotel was designed to be the focal point of the entire complex having been built directly above the existing station. A new entrance from Rutland Street, featuring ornate iron gates that are still there today, provided the station with adequate vehicle access.

Up until the end of the Second World War, Princes Street station thrived. It became the preferred arrival destination for the British monarchy on state visits to the city. Its ease of access to Princes Street was deemed an absolute necessity for the purpose of processions, with the alternative prospect of tackling the steep inclines of Edinburgh Waverley seen as being significantly less favourable. However, in 1948 with the advent of nationalisation across Britain's numerous railway networks, Princes Street station, despite its size, opulent interior and regal approval, was deemed surplus to requirements. Over the following seventeen years, service was reduced gradually station by station, sleeper by sleeper, until September 1965, when the grand Princes Street terminal finally met the end of the line.

Caledonian Railway Company's Princes Street Station Hotel, Edinburgh.

The Caledonian station.

THE EDINBURGH DISTANCE MARKER

This innocuous looking bollard, which stands outside what are now the Waverley Gate offices on Waterloo Place at the east end of Princes Street, is passed every day by thousands of people without much thought. Its importance derives from the fact that the Waverley Gate offices were formerly the main post office for Edinburgh and the bollard was the marker for all distances to and from Edinburgh. It can, therefore, perhaps be considered as the centre of the city. All street numbers in Edinburgh also start at a point nearest the bollard. It is unfortunate that in recent years it was moved a few metres west of its original location from the middle of the frontage of the old post office building.

The Edinburgh distance marker.

THE INCH POSTBOX

In 1952, as the Queen's Coronation approached, the Post Office decided to mark the occasion by erecting a new postbox marked EIIR in honour of the new monarch. On 28 November 1952, an official party assembled at the junction of Gilmerton Road and Walter Scott Avenue – part of the Inch Estate, the council's newest housing development, to formally unveil the postbox.

What at first appeared as a perfectly appropriate recognition of the new Queen, quickly became an event which received close attention from the media, caused questions to be asked in the House of Commons and required police surveillance of the postbox. The problem was that Queen Elizabeth I had never been Queen of Scotland and the marking of the box with EIIR was considered inaccurate and quite unacceptable to some people.

Shortly before the official unveiling of the postbox, a pressure group had written to a number of officials to question the legality of using the EIIR symbol. The authorities were aware of the controversy and five police officers were present at the unveiling ceremony.

Despite the box receiving special police attention, within 36 hours the EIIR symbol had been defaced. A week later a parcel containing gelignite was found in the postbox. On 2 January 1953, a postman found another explosive charge. All was quiet for the next few weeks until, on 7 February, two workmen saw a man vandalising the box with a sledgehammer wrapped in a sack. The attacker ran off and the damaged pillar box door had to be removed for repair.

The Inch postbox.

Finally, on 12 February 1953 at around 10 p.m., the area was rocked by an explosion which could be heard 1 mile away. The postbox had been completely blown apart. The next day, a small Lion Rampant was found on the ruins of the postbox. Within two days a new postbox appeared with no sign of EIIR. The issue was debated in the House of Commons, but there was no conclusive decision on the use of EIIR. The events had alarmed local residents, and they made it clear that, for safety reasons, the erection of another box with the identification EIIR would not be welcome.

CASTLE BOUNDARY MARKER

The War Department marked the land boundaries of military establishments by small rectangular stones, usually inscribed with a number and the initials or markings of the parent Ministry.

Twenty-seven War Department March Stones were placed to mark the boundary of Edinburgh Castle. Each stone is made of sandstone and engraved with 'W. D.' for War Department, plus a Roman numeral. This one is near the exit from Princes Street Gardens into King's Stables Road.

Castle boundary marker.

POLICE LANTERNS

A metal frame and lantern at the corner of North Bridge and the High Street is an old form of communication for the police. The lanterns were usually attached to the Edinburgh police boxes, but the one at North Bridge is completely separate. The lanterns would flash when the police station wanted to contact the police officer on the beat. The police officer had a set path to walk and he had to check in with the station at agreed times. If he didn't check in or respond to the lantern then someone would be dispatched to investigate.

Edinburgh's police boxes were designed by city architect E. J. MacRae in the 1930s, to complement the classical architecture of Edinburgh, and are a distinctive feature of the city.

EDINBURGH'S WILD WEST TOWN

There is a surprising bit of the Wild West in a lane at Springvalley Gardens in Morningside. There's a saloon, a jail and stables – you almost expect the gunfight at the OK Corral to start. It was constructed in the mid-1990s as an advertising feature for a furniture company.

NELSON MANDELA

The inscribed stone at the front of the city chambers on the High Street shows Nelson Mandela's prison number. Nelson Mandela received the Freedom of the City of Edinburgh in October 1997 and, in August 2009, Annie Lennox unveiled the stone memorial to honour the city's links with Nelson Mandela. The stone also features handprints from Annie Lennox and a 15-year-old boy with HIV.

Police lantern.

Edinburgh police box.

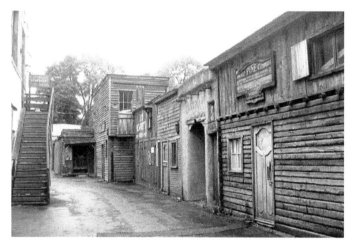

Edinburgh's Wild West Town.

Nelson Mandela's prison number.

THE '99' ICE CREAM CONE

Was Portobello the home of the classic ice cream treat the '99' cone? The Oxford English Dictionary's provides the following explanation of the '99's' origins:

> Ninety-nine (also '99'), an ice cream cone made with soft ice cream with a stick of flaky chocolate inserted into it. The first printed reference to the 99 is in 1935: Price List Cadbury Bros Ltd. Aug., '99' C.D.M. Flake (For Ice Cream Trade. 1936 in Advertising Album – Try a '99' ice cream with Cadbury's Dairy Milk Flake chocolate.

The dictionary provides the possible origin of the phrase as coming from using '99' to describe something as first class, referring to an elite guard of ninety-nine soldiers in the service of an Italian king.

However, an ice cream shop at No. 99 Portobello High Street has a strong claim to being the home of the '99'. The shop was opened by Stephen Arcari in 1922 and the family believe that Stephen first broke a flake in half to top-off a cone around that time, and that the ice cream was named after the address of the shop.

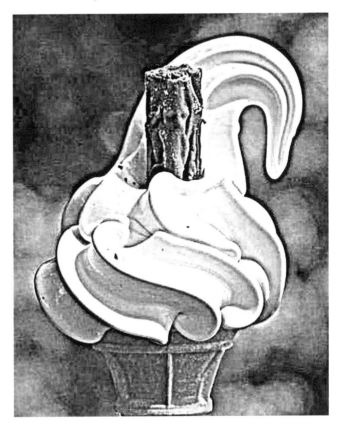

A '99' ice cream cone.

Arcari's ice cream shop, No. 99 Portobello High Street.